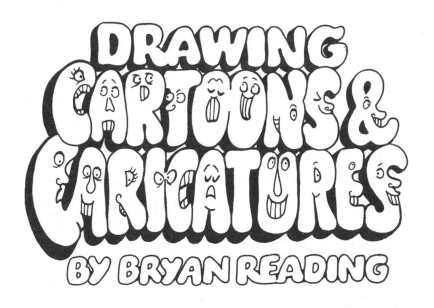

DRAWING CARTOONS & CARICATURES

BY BRYAN READING

*Other titles illustrated
by Bryan Reading*

The Awful Joke Book
The Even More Awful Joke Book
The Most Awful Joke Book Ever
The Funniest Funbook
The Batty Book Book
The Batty Cartoon Book

Drawing Cartoons and Caricatures
was first published in Armada
in 1987 by Fontana Paperbacks,
8 Grafton Street, London W1X 3LA

Armada is an imprint of
Fontana Paperbacks, part of
the Collins Publishing Group

Printed and bound in Great Britain by
William Collins Sons & Co. Ltd, Glasgow

FOREWORD

What on earth is Bryan Reading up to? I mean, for heaven's sake! Here we all are, us professional cartoonists trying to earn an honest crust, hoping that newspaper editors will continue to think of us as a rare breed and what does he do? He spills the beans! Tells the whole world how it's done! Soon the magazine and newspaper industry will be awash with Bryan Reading clones, all beavering away and putting the rest of us into the dole queues. Editors might even read his book and decide to save money by doing it themselves.

Why couldn't he have written something useful on frog spawn juggling or keeping fit the Pygmy way? Why also was this book not around when I was trying to get started as a cartoonist?

How wonderful it would have been to have had a ready reference book at hand to help with facial expressions, body proportions, shading techniques, the type of pen to use, etc., etc.

Looking back at my own early efforts, they were pretty crude attempts at humorous drawing. Some were my own misshapen inventions and some copied from *The Beano* and *Dandy*. I used to think that to be funny all a cartoon character needed was to have teeth missing, knobbly knees, crossed eyes and big feet.

If only I had had this book, I would have realized earlier in my career that humour can be portrayed in a much more subtle way and that it is not necessary to go 'over the top' with body and facial contortions to draw an amusing cartoon.

Some people think that the gag is the most important ingredient of a cartoon. But how easy it is to ruin a really good joke by a really bad drawing. So if all you would-be cartoonists out there are lucky enough to have good ideas and Bryan Reading's book ... Why, you can't go wrong!

Mac

A LITTLE HISTORY *(Not too boring)*

A CARTOON originally was a preliminary sketch or rough layout for a large painting or mural. In 1843 the Palace of Westminster exhibited some of the cartoon entries for a competition to cover the walls of the new Houses of Parliament with historical and uplifting paintings. *Punch* magazine took this opportunity to publish their own satirical view of how Parliament should be decorated. They called the series *Punch's Cartoons*. In this way a cartoon has come to mean **any** sort of comic drawing.

A CARICATURE is an exaggerated portrait. The word stems from the Italian *'caricare'* meaning 'to overload'. This is a good description, for we are overloading our drawing so that it is not only a likeness of the victim, but it also says something about his character or personality. Our national newspapers carry good examples of political and social caricature.

You can wake up now

INTRODUCTION

Everyone has a sense of humour, the trouble is that everyone has a **different** sense of humour. A joke which will raise giggles in one reader will not twitch an eyebrow in another. All cartoonists suffer from this. A batch of ten cartoons sent to an editor might include four or five red hot surefire whizzo ideas, the rest will be makeweights, just there to make up numbers. The red hot surefire whizzo ideas will come whizzing back and the editor will probably keep the supposed no-hopers!

All this goes to show that humour is subjective, or different for everyone.

Should cartoons be well drawn?
It is sometimes argued that the drawing doesn't matter, it is the **joke** that is important. But bad drawing, like bad handwriting, is an insult to the reader so give pleasure with good drawing. You won't find shoddy drawing in top cartoonists' work.

STARTING OFF

Next time someone near you picks up a newspaper or magazine, watch them carefully. They will look at the pictures before the text.

Images have a strange power to attract attention.

After all, early man could draw before he worked out an alphabet, just as you would draw before you learned to write.

Cartoon drawings tell a joke or make a point **quickly**.

Of course jokes **can** be set out in type, but they lose a lot of their impact this way

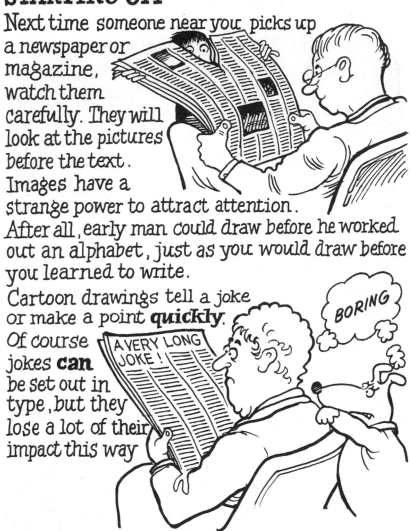

A VERY LONG JOKE!

BORING

FINDING A STYLE

It is often very difficult for young artists to find a personal style. Cut out copies of drawings you like, trace them off, and study the way effects are achieved. Your own style will appear. Don't be afraid to copy; after all, it is a compliment to the artist you admire.

As long as a joke gets across to the reader, it doesn't matter if the drawing is a hurried scribble or full of careful detail. The trend these days is toward a light relaxed style. Any old bound copy of *Punch* will give lots of examples of fine artwork, although often the amount of drawing got in the way of the joke. In the days before television more attention was given to the printed page, and a carefully shaded drawing meant value for money. Don't forget - a good joke can be drawn badly and **still** be funny, but good drawing won't save an unfunny joke !

CARTOONIST TYPES

The POCKET CARTOONIST draws the small, single column cartoon, usually on the first page of your newspaper. He usually waits to the last minute to get the joke as topical as possible which is why a pocket cartoon will appear on the news pages which are put together last.

*

The SOCIAL CARTOONIST has a lot more space. His work appears daily, often on the diary or gossip pages. Usually the social cartoonist is the most easily recognized by the general public.

Both the Pocket and the Social Cartoonist show rough ideas to the editor before proceeding to finished art.

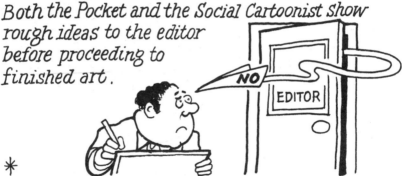

*

The STRIP CARTOONIST produces his work weeks ahead of publication. Some are drawn specially for the paper, some are syndicated, that is, imported from another country, often America.

*

The FEATURE CARTOONIST illustrates various sections of the paper, such as the Money Section, the Sports Section, the Women's Pages and so on.

The SINGLES CARTOONIST is a freelance who produces the drawings that go to make up the 'Fun Section'. These are jokes drawn to a simple format to fit any shape they may be crammed into.
There are more singles cartoonists working today than any other type.
*
Newspapers are not the only field in which cartoonists may work. Most are willing to tackle book illustration, advertising work, greetings cards, T.V. animation, audiovisual displays and house and trade magazines.
*
I've used the word 'he' when describing the cartoonist. It is a sad fact that there are very few women cartoonists at work today. No one knows why but some cartoonists say that this is because women have more sense!

What sort of cartoonist are **you** ?
I will assume that you can draw a hit and want to say something amusing about the world around us. You may want to make a comic poster, or illustrate a school or club magazine, or produce a greetings card.
I hope this little book will help.

MATERIALS

Drawing materials are absurdly simple.
You need a soft pencil, say an HB, a soft rubber,
any pen that makes a mark, and some paper.

Most cartoonists draw in black ink on ordinary
A4 size typing paper. This paper is easy to store,
cheap to post (cartoonists rely a lot on the
postal service) and, if a mistake is made,
a fresh sheet can be plonked on top and traced
directly through to save time.

Black ink or black fibre tip pens are used
because blue or other colours will not
reproduce well for the printer.

A brush can give a beautifully flexible line
but it does need a lot of practice. Best to start
off with a fountain pen, or a fibre tip pen.

All we need now are some ideas!

PS: Fibre tip pen drawings will fade away in time

BODY TYPES

In real life there are as many body types as there are bodies — but from the cartoon point of view, we start life chubby

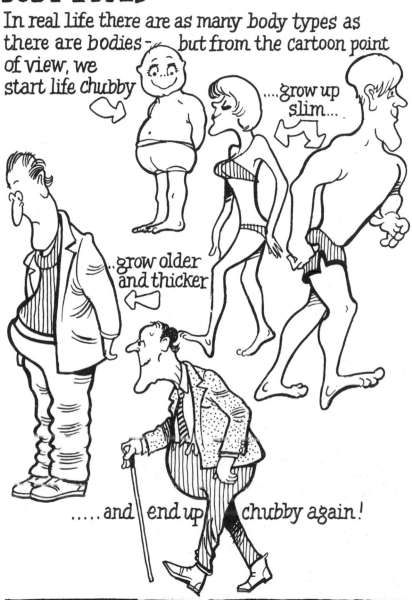

....grow up slim....

..grow older and thicker

.....and end up chubby again!

BLOCKING IN

Use a soft pencil to rough out your first shapes. Concentrate on the movement, don't worry about proper proportions.

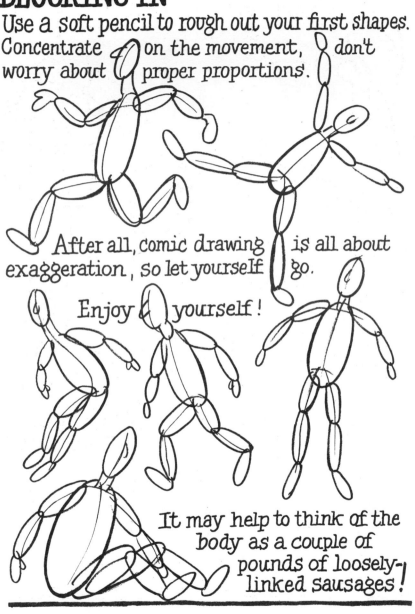

After all, comic drawing is all about exaggeration, so let yourself go.

Enjoy yourself!

It may help to think of the body as a couple of pounds of loosely-linked sausages!

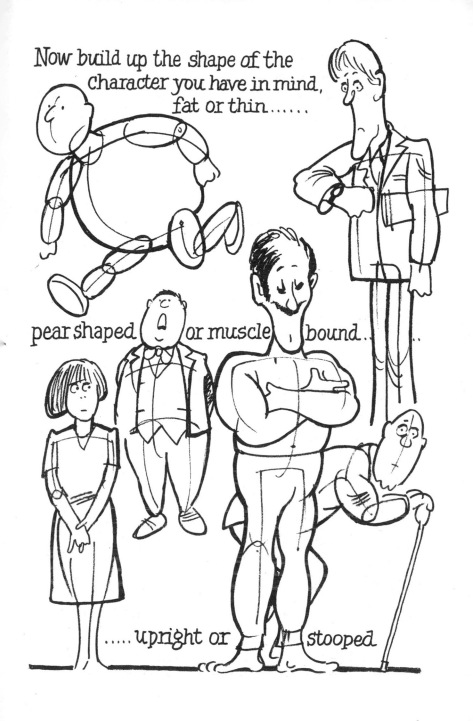

Now build up the shape of the character you have in mind, fat or thin......

pear shaped or muscle bound......

.....upright or stooped

DRESSING UP

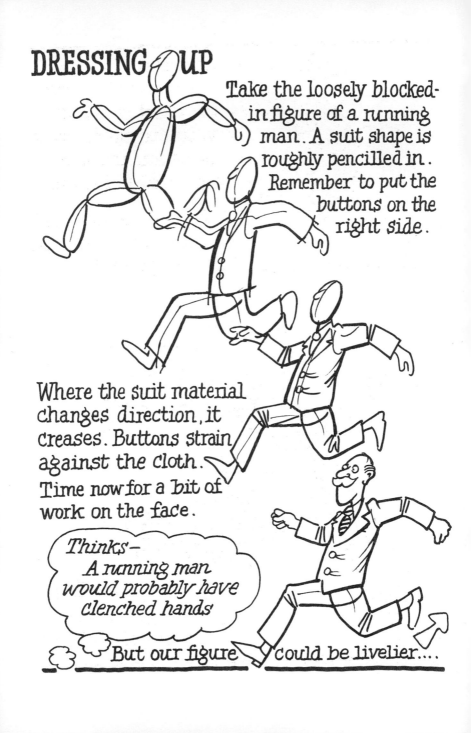

Take the loosely blocked-in figure of a running man. A suit shape is roughly pencilled in. Remember to put the buttons on the right side.

Where the suit material changes direction, it creases. Buttons strain against the cloth. Time now for a bit of work on the face.

*Thinks—
A running man would probably have clenched hands*

But our figure could be livelier....

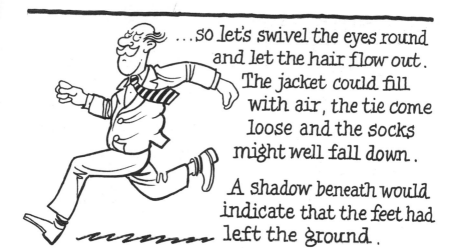

...so let's swivel the eyes round and let the hair flow out. The jacket could fill with air, the tie come loose and the socks might well fall down.

A shadow beneath would indicate that the feet had left the ground.

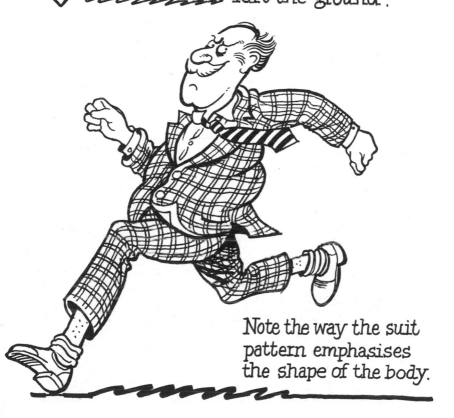

Note the way the suit pattern emphasises the shape of the body.

CARTOON CLICHÉS

Cartoonists rely a lot on the cartoon cliché. Have you ever seen a complaints desk? Or a boy scout wearing a bush hat? Cartoonists use them all the time!

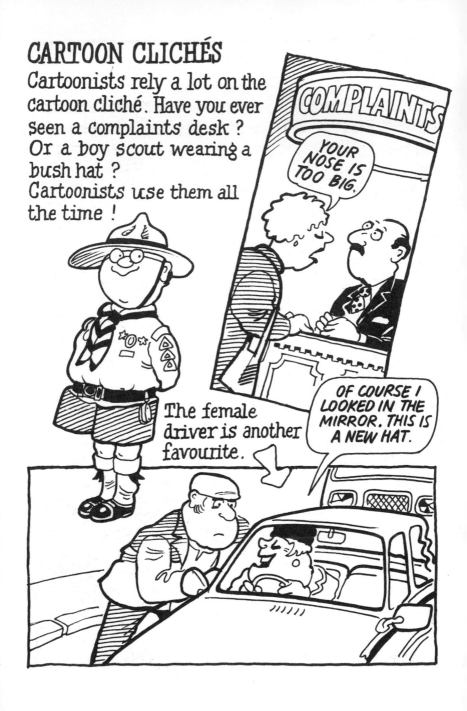

The female driver is another favourite.

One advantage of using a cartoon cliché is that your reader will recognize the subject, and be halfway to understanding the joke before reading the caption. Other common clichés are jokes about mothers-in-law, and wives waiting for latecoming husbands with rolling pins !

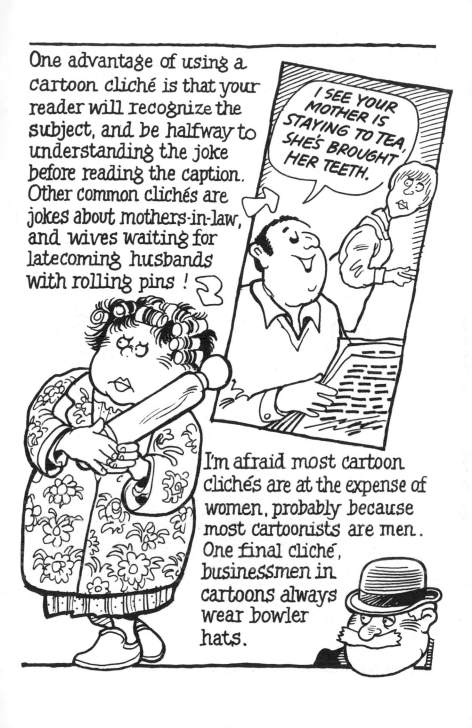

I SEE YOUR MOTHER IS STAYING TO TEA, SHE'S BROUGHT HER TEETH.

I'm afraid most cartoon clichés are at the expense of women, probably because most cartoonists are men. One final cliché, businessmen in cartoons always wear bowler hats.

WHAT MAKES IT FUNNY?

No one knows **how** humour works, although many academics have written about the psychology of humour. Most cartoonists rely on a sort of organized mind wandering, pushing an idea around until something clicks. However many gags **do** fall into four main groupings :-

① *THE UNSEEN FACTOR* is a joke in which the reader sees more than the cartoon character.

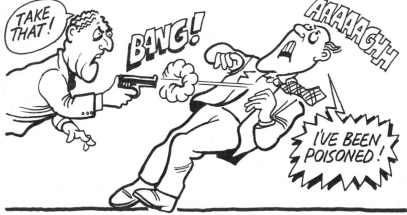

② *THE SWITCH JOKE* is a system where we are led to believe that one thing is about to happen, but are then surprised by another!

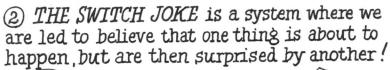

③ *THE UNDERSTATED JOKE* has a character reacting to an event in an unexpected manner.

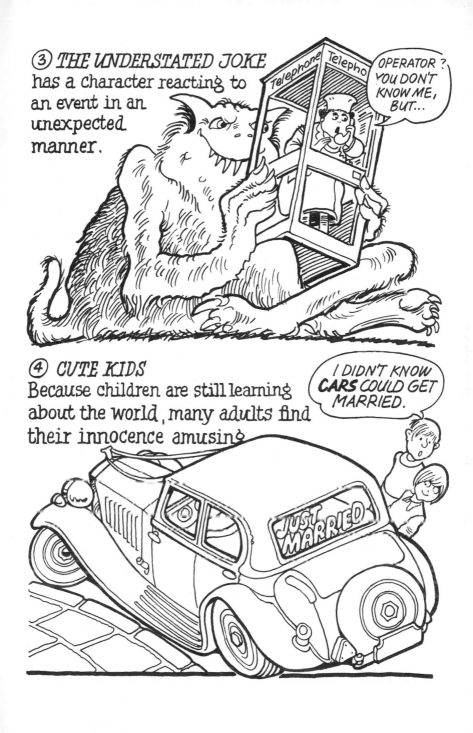

④ *CUTE KIDS*
Because children are still learning about the world, many adults find their innocence amusing

HANDS are the most expressive part of the body, and, alas, the most difficult to draw!

Only shove hands into pockets if it is the right thing for the character to do.

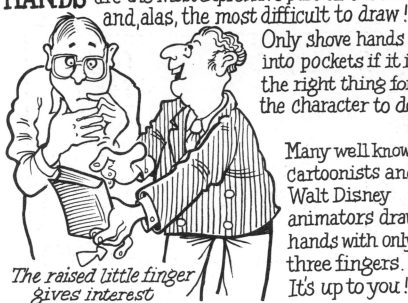

The raised little finger gives interest

Many well known cartoonists and Walt Disney animators draw hands with only three fingers. It's up to you!

Don't just hang hands on to the ends of arms like a bunch of bananas! Carefully-drawn hands can tell a lot of the story.

They can point, beg, threaten or pray.

MORE HANDS

Sometimes there is no need to show a face at all.

Try and let the hands tell the story.

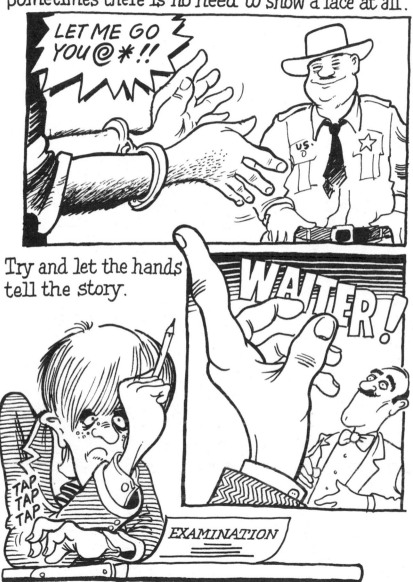

YOUR COUNTRY NEEDS **YOU** Perhaps the best-known hand in the world ! This is a detail from a famous First World War recruiting poster.

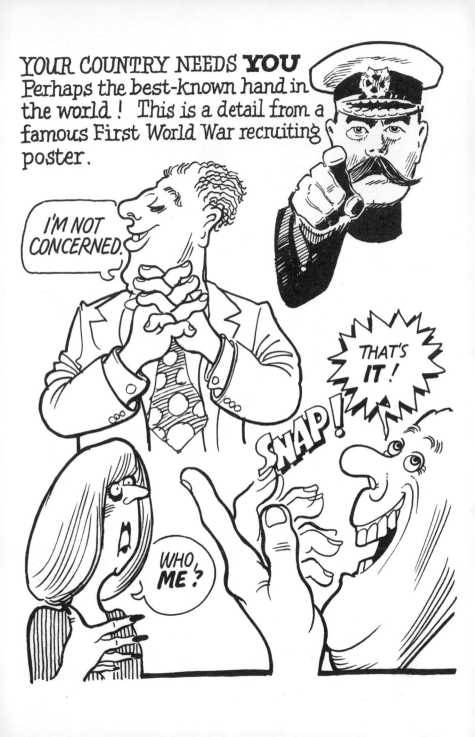

FACE SHAPES

Decide which face you want.

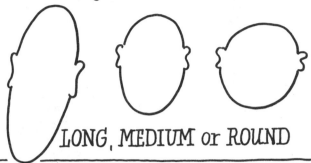

LONG, MEDIUM or ROUND

When looking for a face to match the character of the subject, in cartoon terms :–

'Long' means gloomy
'Medium' means normal
'Round' means jolly

EXPRESSIONS

Let's take a typical middle-aged slightly fleshy male face.

With only a few small changes we can produce about every variation we need.

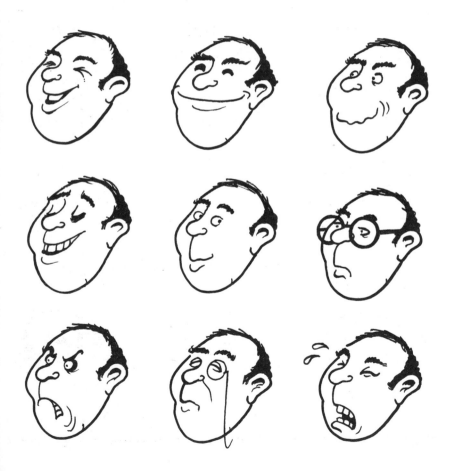

Now let's dress our face up with a few more props.

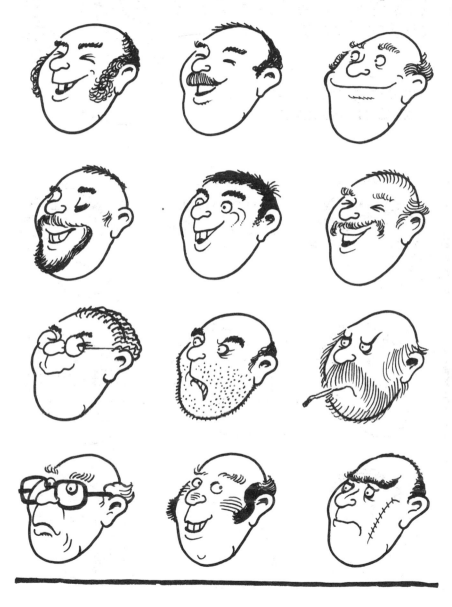

EYES

Eyes are the only feature that don't grow much, that is why a baby's eyes seem so large in proportion to its head

Note:
Make sure that the eyeball positions match exactly · Like buses they move about together!

Eyeballs can help with emphasis.

Eyes can look:
- upwards in frustration

- down in arrogance

Eyes can:
- get crossed in confusion

- narrow when angry

Eyes can:
-widen in
horror or
surprise

-wink

Eyes can be
bloodshot

or suggest
giddiness

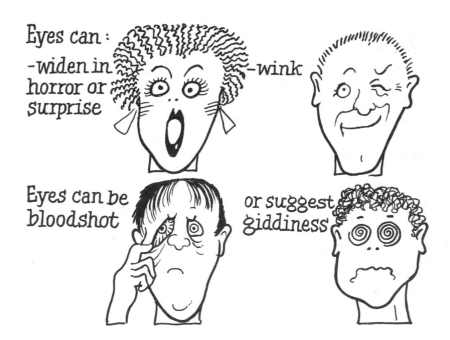

Don't forget that women use eye make-up to
make eyes appear larger and eyelashes thicker

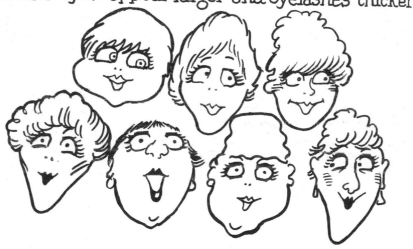

THE MOUTH
Can say a lot !

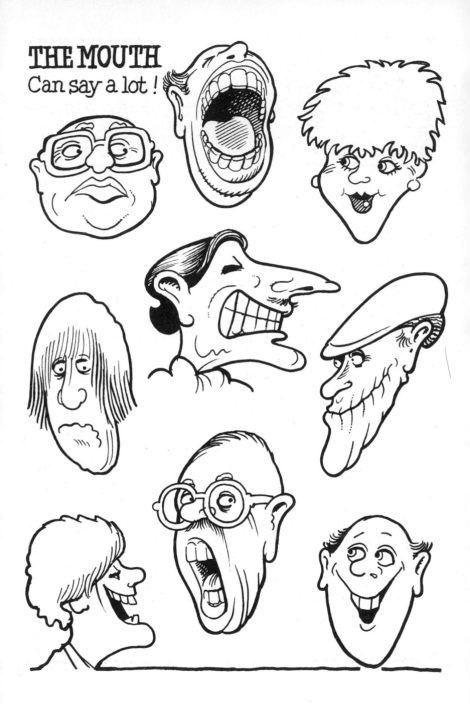

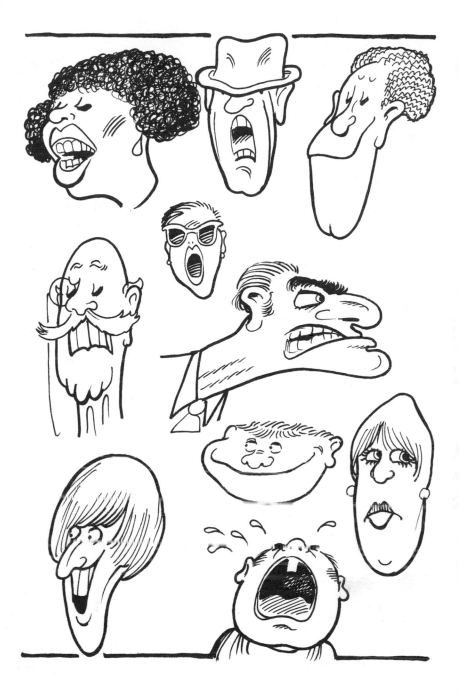

FEET

Make sure the feet and the footwear fit the character.

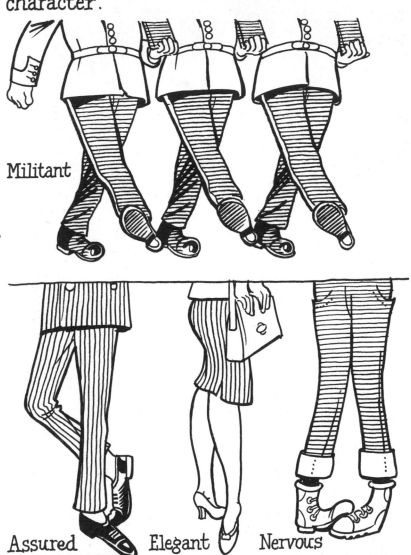

Militant

Assured Elegant Nervous

It's easy to forget most of us have a right **and** a left foot. Remember that they tend to curve toward one another !

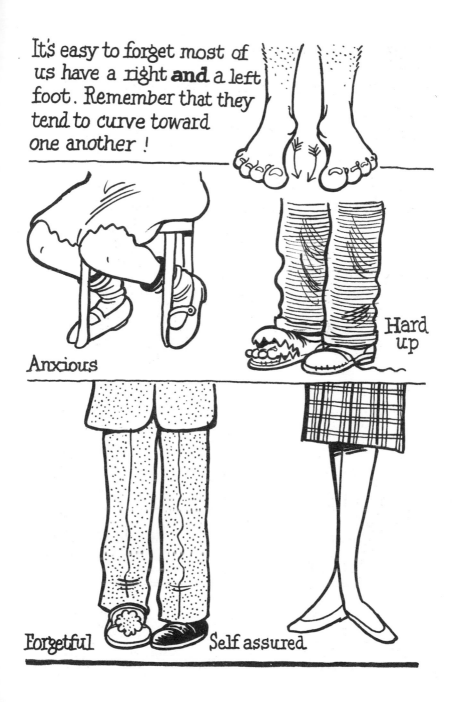

Anxious

Hard up

Forgetful Self assured

SHADING TINTS

Professional cartoonists often use self-adhesive shading tints for speed and convenience. But as these sheets are quite expensive, we can draw most of the patterns ourselves. See how the patterning throws the cartoon faces forward.

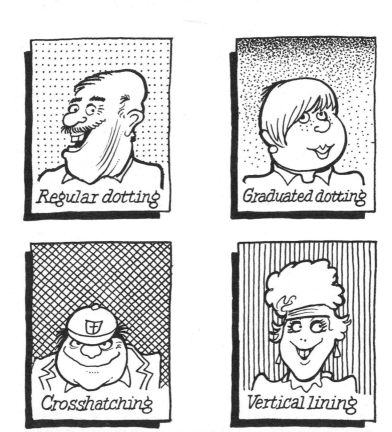

Regular dotting

Graduated dotting

Crosshatching

Vertical lining

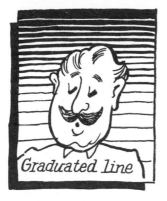

Graduated line

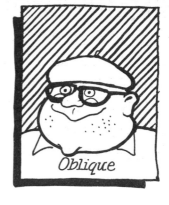

Oblique

Splatterwork

Decorative

Birdsfoot

Seawave

SHADING

There are no rules about shading; this is a matter of personal style. Here are some examples.

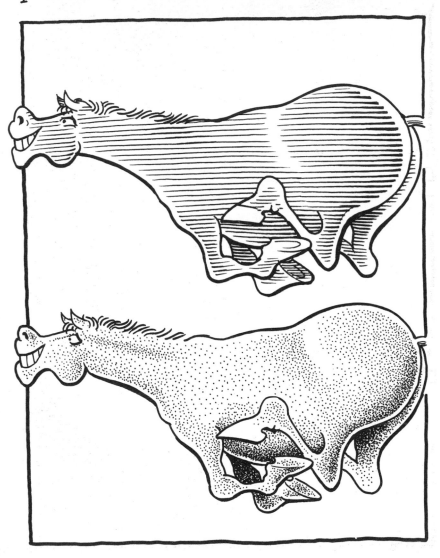

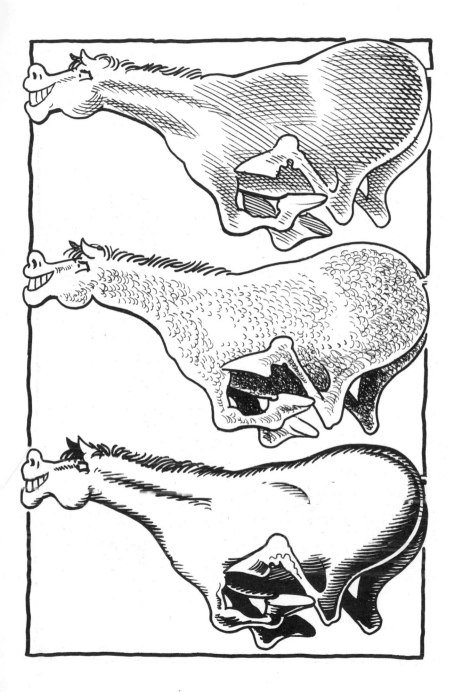

MORE SHADING

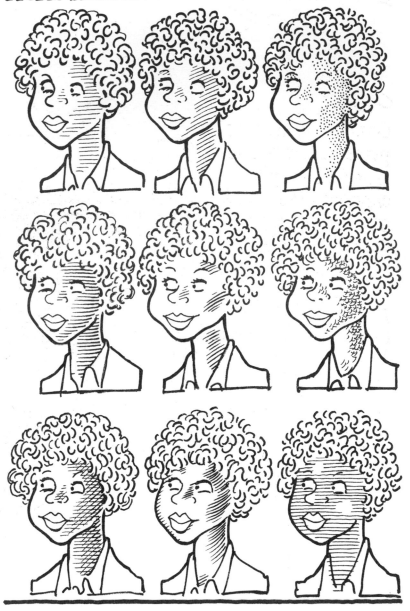

SPLATTERWORK

Cover the appropriate parts with masking tape and spray the exposed area, using a toothbrush dipped in paint or ink

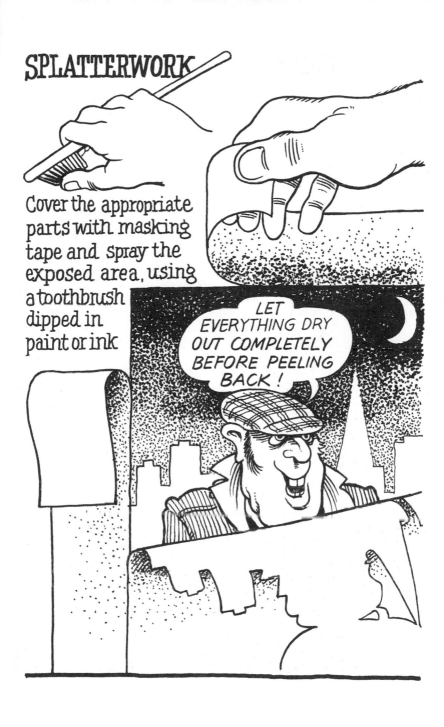

SILHOUETTES

Making a silhouette was a very popular Victorian pastime, perhaps because the final result could be more flattering than a drawing.
It's not as easy as it looks, but give it a try.
Obviously a strong profile is most important.

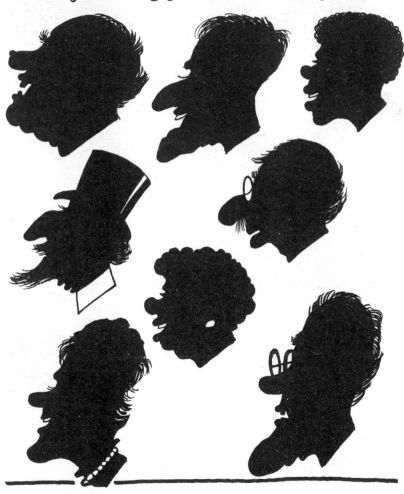

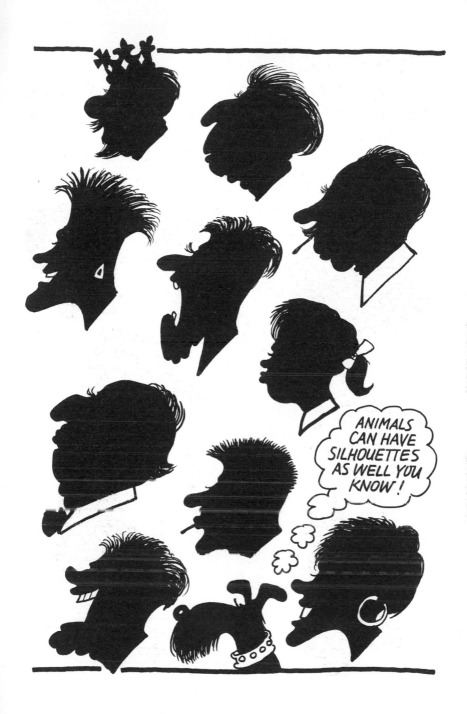

UPSIDOWN !

A bit of comic fun. Try to draw a face which works upside down and right way up.

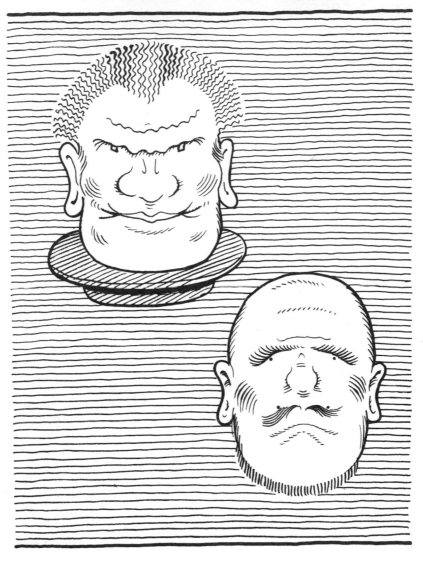

SQUARING UP

Here is a simple way to enlarge an existing figure. Pencil a grid over the subject, number and letter this grid then transfer the drawing to a larger pencilled set of squares.

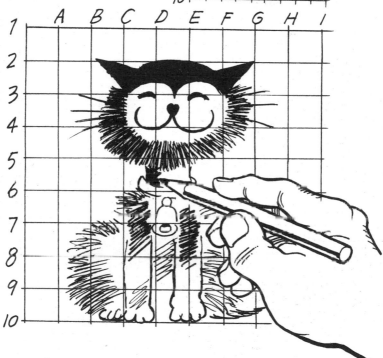

SHADOWS
A thrown shadow will add interest and drama.

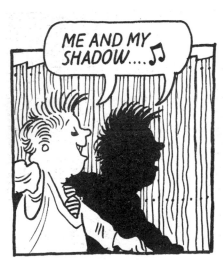

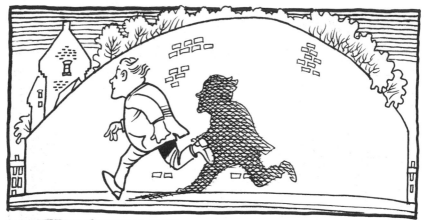

A solid shadow
binds the two
heads together

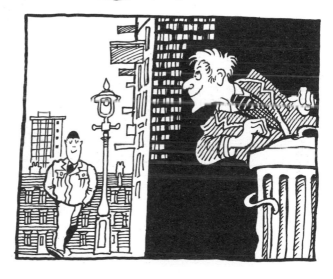

PRESENTATION

Here is a straightforward joke. How can we present it in the best way?

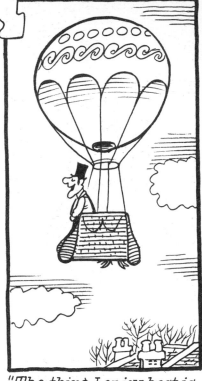

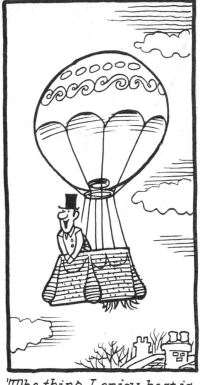

"The thing I enjoy best is the silence, Henry"

"The thing I enjoy best is the silence, Henry"

How about turning the basket around?

A bit more interest, but could be more exciting. Do we need to show the whole balloon?

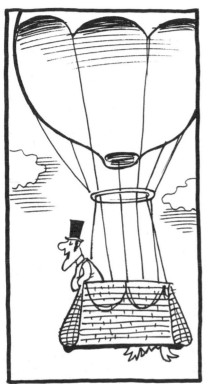

"*The thing I enjoy best is the silence, Henry*"

"*The thing I enjoy best is the silence, Henry*"

This gives us a better understanding, but if we take a view from beneath, we will get —

the best option.
The open space beneath suggests danger. We can't miss the point now!

ORGANIZING A STRIP CARTOON

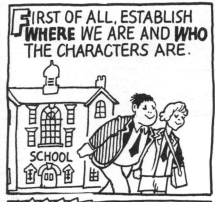

FIRST OF ALL, ESTABLISH **WHERE** WE ARE AND **WHO** THE CHARACTERS ARE.

SCHOOL

I SPEAK FIRST, SO MY BUBBLE COMES FIRST.

SEE IF I CARE.

HELP, IT'S GONE ALL **DARK**!

IF NOTHING EXCITING IS HAPPENING, A SILHOUETTE WILL KEEP THINGS MOVING.

CLOSE-UPS ARE ANOTHER WAY OF VARYING THE INTEREST.

I'M GLAD I COMBED MY HAIR.

IF NOTHING HAPPENS SOON, I'M GOING HOME.

CAN I COME?

Because we read from left to right, cartoon characters usually move in that direction.

We can learn a lot from television and the cinema.
The actors always look **into** the picture area —

and they always **move** in the same direction.
Viewers would soon get confused if **this** sort
of thing happened.

Strip cartoons
should follow this rule !

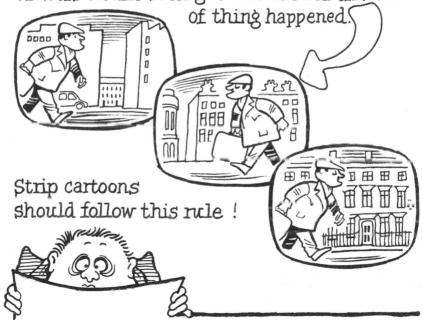

PLACING THE SUBJECT

If the main subject is looking ahead,
show a space ahead

If looking behind, leave a space behind

PRESENTATION

Here is a straightforward joke – can we improve it?

Perhaps we could make the executioner bigger and more threatening

That's better, but don't forget we are in a prison. This view is probably best. The solid black shadow pulls the scene together.

THUMBTHING SPECIAL

Several eminent cartoonists have used the inked thumb technique to produce an interesting sky. Use poster paint, as drawing ink is usually too thin to get results.

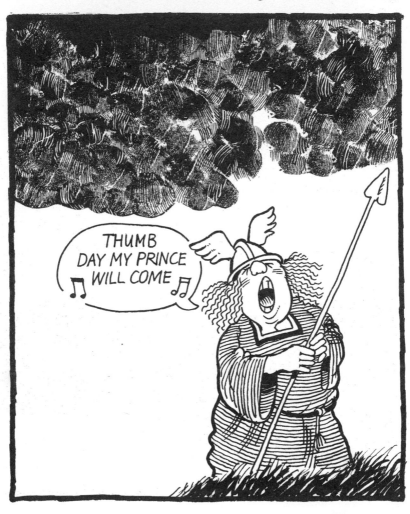

BREAKING OUT

For extra impact, make a character burst right out of the outline frame.

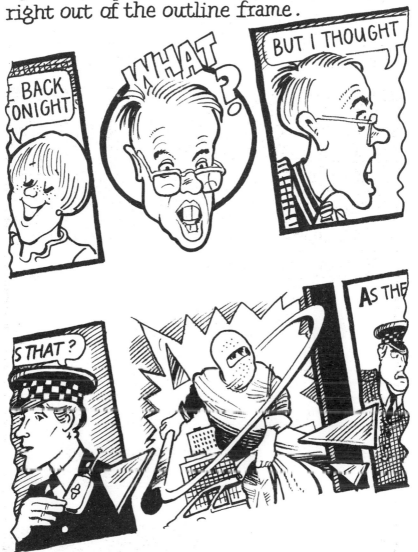

GLASSES

Look out for ways to use specs in an interesting way.

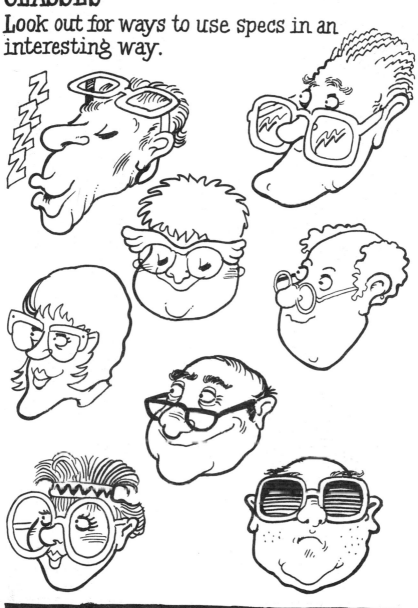

ON THE MOVE

To give a sense of speed draw vehicle wheels leaning forward.

When braking hard the opposite happens.

Some lettered words can be useful. Note the way the letters overlap to give the impression of speed.

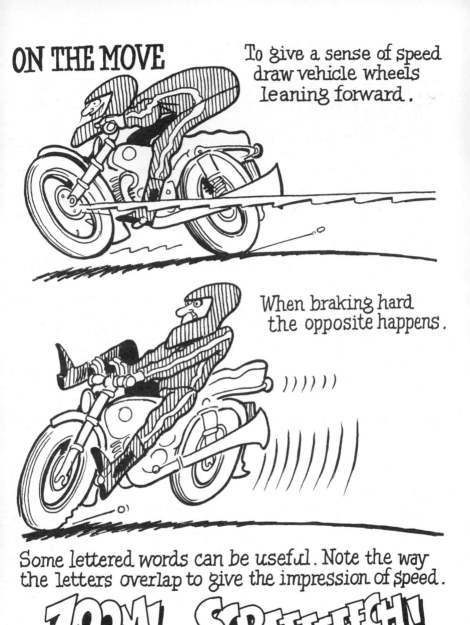

ON THE MOVE

Most cartoonists use a variation of the exhaust cloud to suggest speed.

This version is popular with television cartoon makers.

Increase the effect by showing the grass being sucked along behind.

Another variation. The shadow shows that the runner has left the ground.

Add to the movement by discarding bits *1* and pieces.

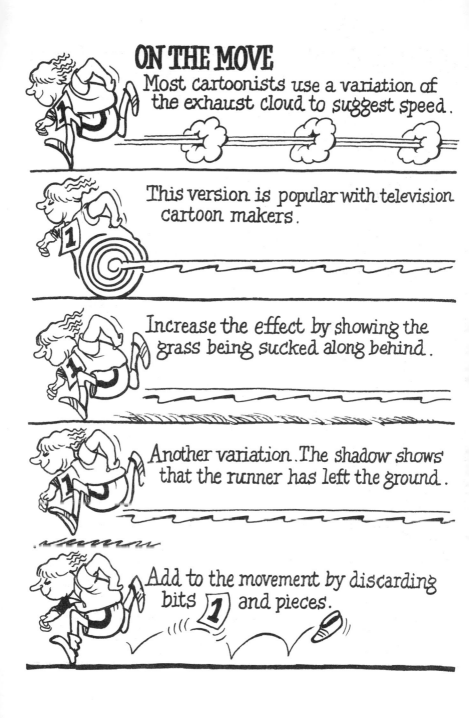

MORE MOVEMENT

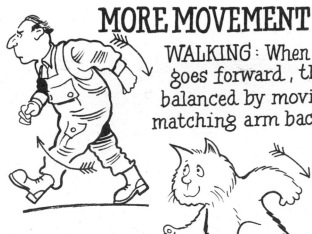

WALKING: When the front leg goes forward, the body is balanced by moving the matching arm back.

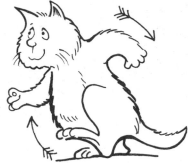

STROLLING:
Because there is no urgency here, the head and shoulders would be thrown back, and the hands relaxed, even put in the pockets.

STILL MOVING

Distortion like this can make the car appear to surge forward. Take a low viewpoint to add drama.

This is another example where a low viewpoint makes the movement a lot more exciting.

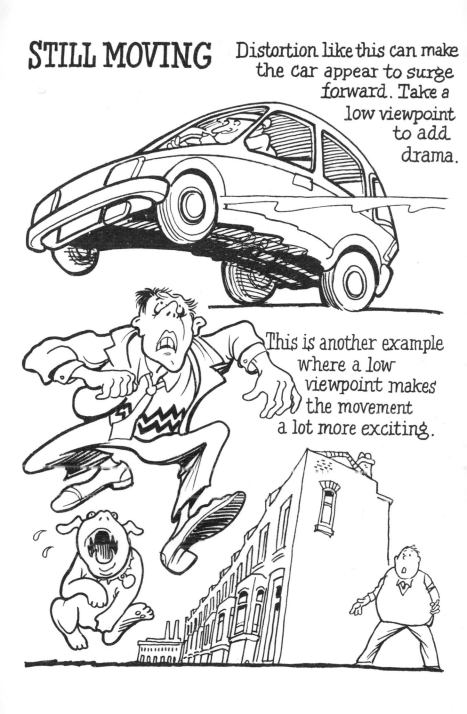

LETTERING

Spend some time on this. Readers will soon get discouraged if they have to wade through wobbly and untidy lettering.

CARTOON STRIPS ARE USUALLY LETTERED IN CAPITALS BECAUSE THEY LOOK NEATER, CAN BE REDUCED IN SIZE AND STILL STAY LEGIBLE.

DON'T BREAK WORDS IF YOU CAN HELP IT – IT LOOKS **UN-TIDY**! PLAN AHEAD.

IF YOU WANT TO EMPHASISE WORDS **THICKEN THEM UP**.

PENCIL IN LETTERING GUIDELINES AND STICK TO THEM · KEEP THE SPACES BETWEEN THE LINES REGULAR.

DON'T *JAM THE LINES TOGETHER – HALF THE LETTER HEIGHT BETWEEN LINES IS A GOOD RULE.*

Not **all** cartoonists manage their own lettering. Some newspapers employ lettering artists to help out.

LETTERING

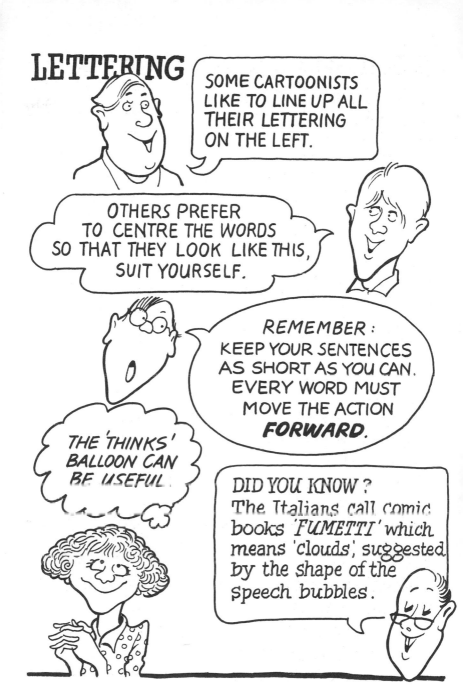

SOME CARTOONISTS LIKE TO LINE UP ALL THEIR LETTERING ON THE LEFT.

OTHERS PREFER TO CENTRE THE WORDS SO THAT THEY LOOK LIKE THIS, SUIT YOURSELF.

REMEMBER: KEEP YOUR SENTENCES AS SHORT AS YOU CAN. EVERY WORD MUST MOVE THE ACTION **FORWARD**.

THE 'THINKS' BALLOON CAN BE USEFUL.

DID YOU KNOW? The Italians call comic books 'FUMETTI' which means 'clouds', suggested by the shape of the speech bubbles.

LETTERING

We can suggest <u>how</u> things are said by the style of the lettering, like this —

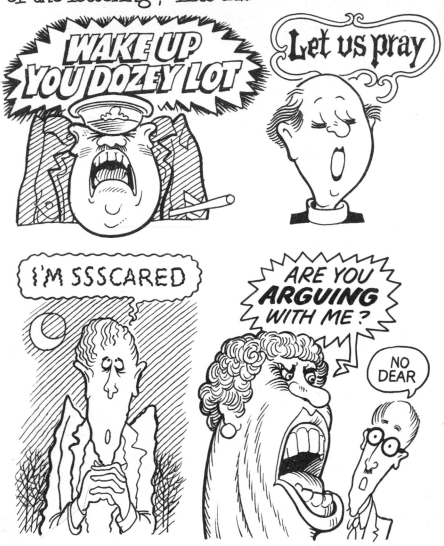

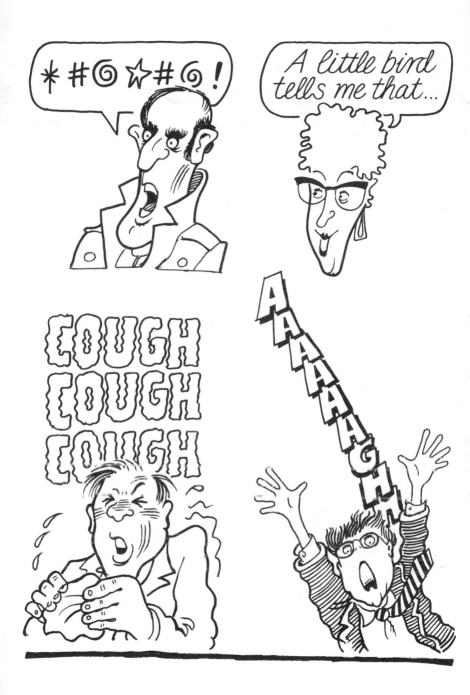

LETTERING

GIVE A BIT OF A BOOST TO YOUR LETTERING WITH A SHADOW INITIAL LIKE THIS.

OR ADD SOME DRAMA WITH WHITE PAINT...

MEANWHILE...

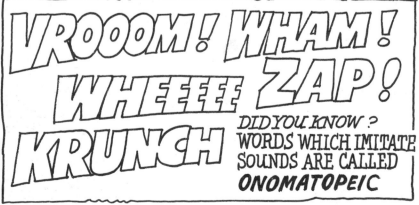

VROOOM! WHAM! WHEEEE ZAP! KRUNCH

DID YOU KNOW? WORDS WHICH IMITATE SOUNDS ARE CALLED *ONOMATOPEIC*

MORE LETTERING

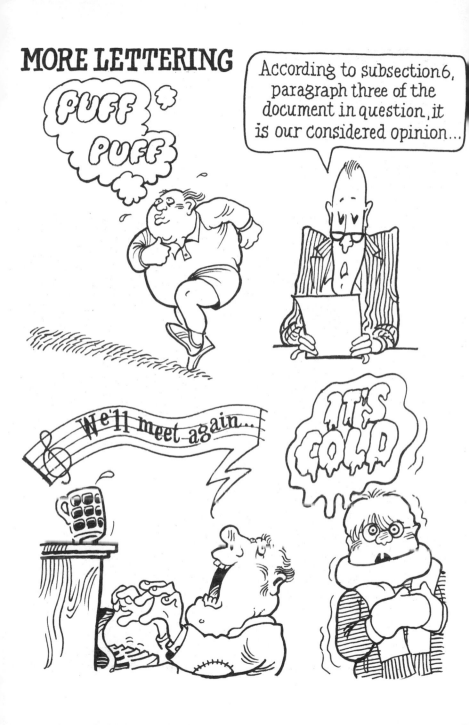

IDEAS

Let us look at a common article like a burglar alarm. What is it for? How <u>else</u> could it stop a burglar? A few moments of organized mind wandering will bring us to a joke solution.

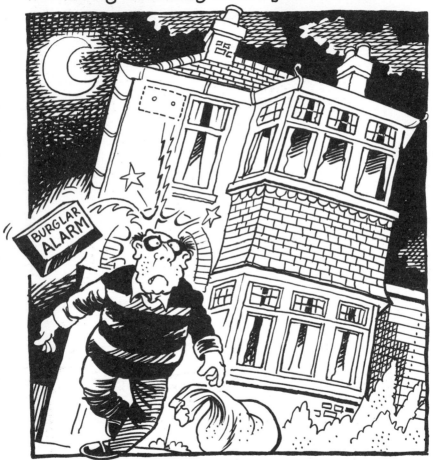

We can add to the shock of impact by tilting the picture angle.

IDEAS

This is an example of 'switch thinking'. We are led to relax by the first sentence, and surprised to laughter by the second.

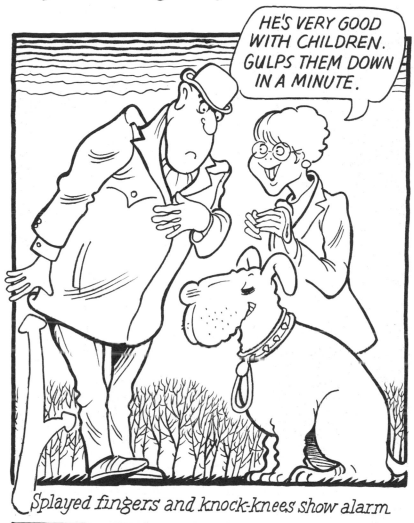

Splayed fingers and knock-knees show alarm

IDEAS

Sometimes just tinkering with words is enough.
Keep an eye open for signs and notices that
can be adapted.

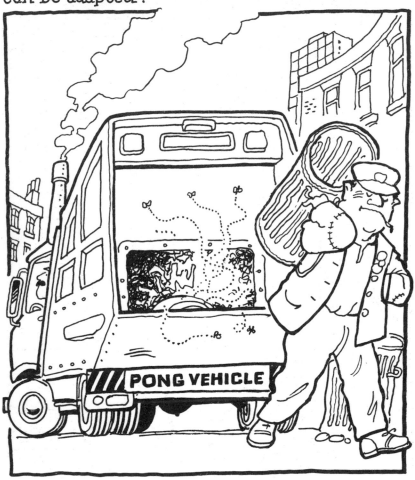

*If we draw the dustcart from a low angle, readers
can't miss the joke.*

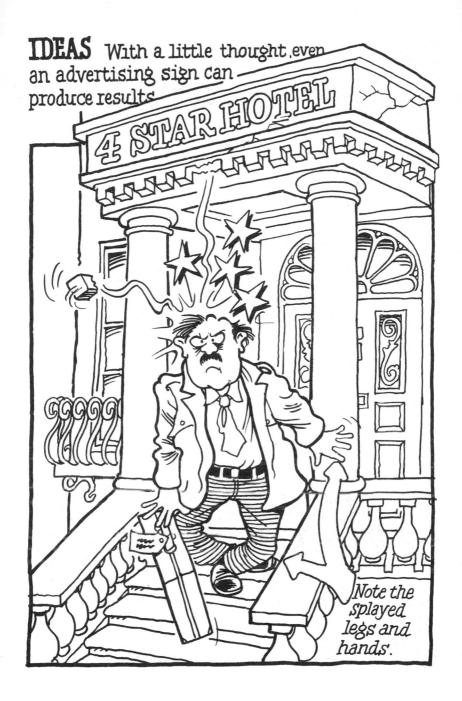

IDEAS

An example of the UNSEEN FACTOR, where the reader sees more than the cartoon character.

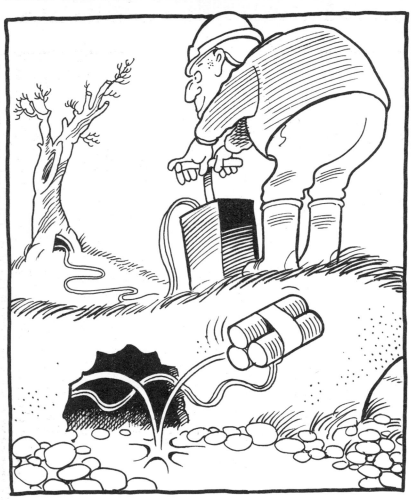

Solid blacks are used to draw the eye to the important parts of the joke.

IDEAS

Another UNDERSTATED joke. The characters carry on as if nothing extraordinary is happening. Once again, black is used to pinpoint the action.

IDEAS

A quite ordinary phrase can have two meanings.

By making the fat lady fill up the foreground, we exaggerate her bulk.

IDEAS
The pawnbroker's symbol sets the scene straight away.

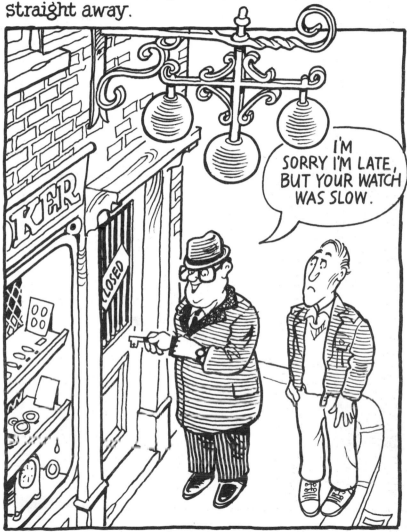

Notice the contrast between the assured pawnbroker and the depressed customer.

IDEAS
Another 'switch thinking' joke.

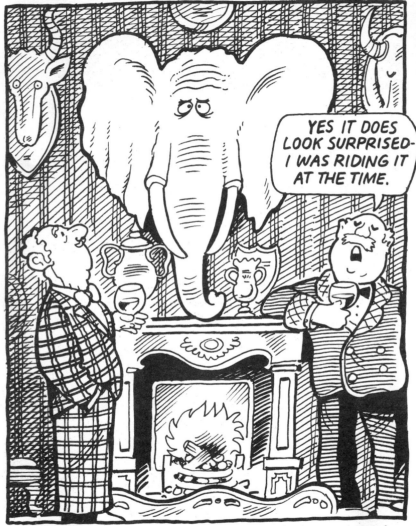

When eyes get close together, the expression becomes more foolish.

SHADING

The same joke, but drawn with a brush on rough watercolour paper.

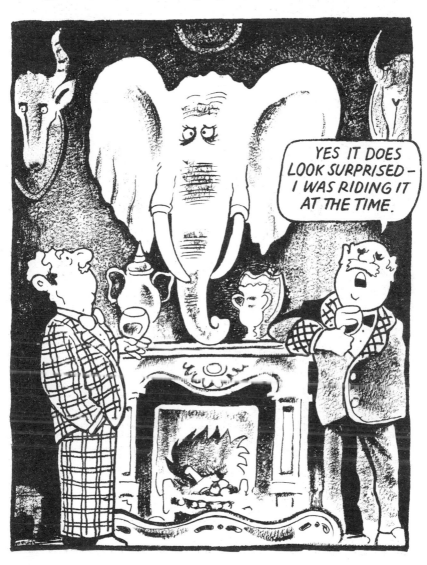

DELAYED REACTION

Sometimes a strip can be made more effective by allowing a space before the penny drops and the joke is realized. Comedians call this a 'slow burn'.

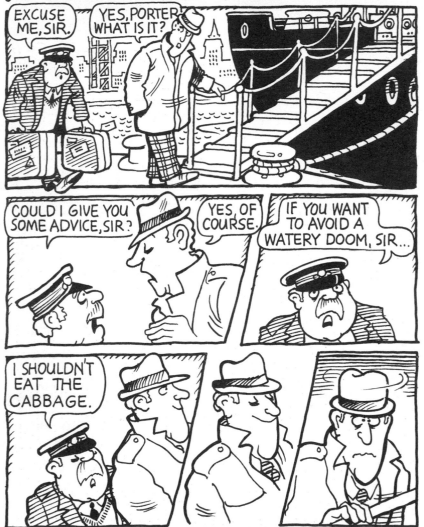

GET THINGS MOVING

Here is a straightforward joke. All right I suppose, but a bit boring to look at.

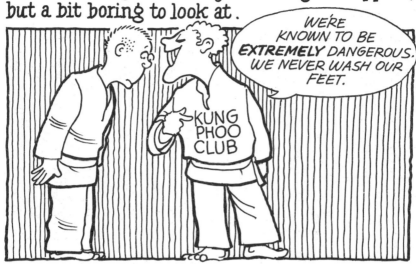

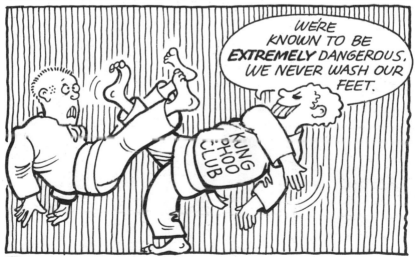

This is a better version; active movement will always bring a drawing to life.

DISTORTION

One pleasure of cartoon drawing is the capacity to distort by choosing one feature and extending it to the edge of recognition. Anything is possible.

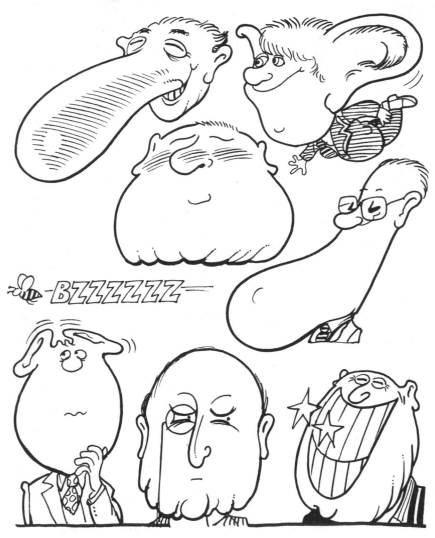

BZZZZZZ

CATCHING THE EYE

Here's a busy scene. How can we see who is doing the talking?

LIGHTING

Increase the drama by lighting the drawing from one side only.

MORE MOVEMENT
A video slow-down technique can be effective.

VIEWPOINTS
A high viewing angle helps to put the point over.

VIEWPOINTS
This drawing couldn't work without a high view.

COMPOSITION

Here the eye is led vertically down by the rainfall to the action at the bottom of the page.

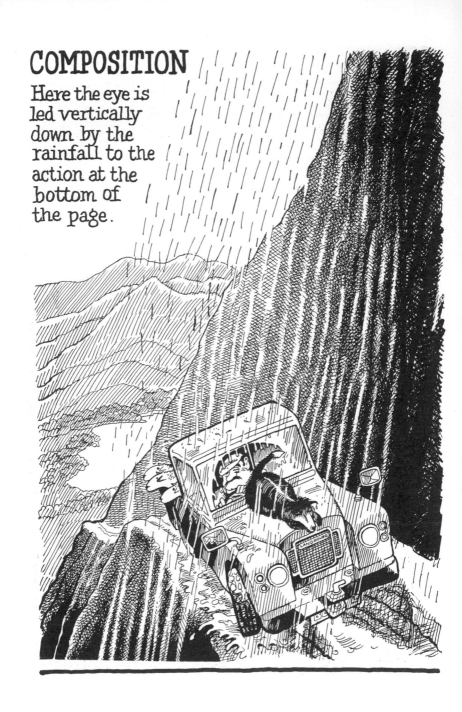

COMPOSITION

An example of a △ triangular composition. Once again by taking a low viewpoint, we can emphasize the main figures and lead the eye up to the clenched fist. Even the heads in the crowd are built up into a triangular shape.

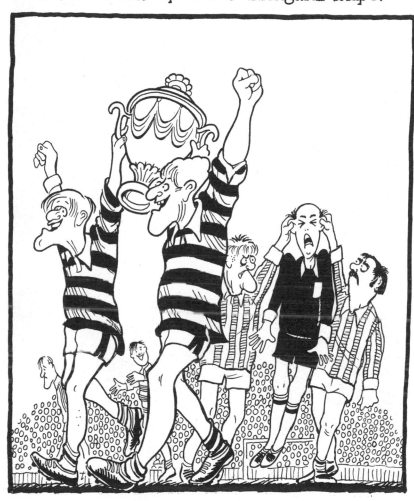

CARICATURE

Now that you are a more confident cartoonist, go a step further and attempt cartoon portraits of people known to you personally.

Let's start by assuming that you want to caricature a classmate. Try to get a photograph so that your victim can be studied at leisure.

Perhaps he looks like this ▷

A normal, roundish face without special features you may think, but look again. We notice that the nose is upturned and shorter than average, the eyelids are heavy, there are a few freckles and the hair is longish and looks uncontrollable.

Now, what do we **know** about this person? He's untidy, a keen footballer and comes bottom of the class at geography! Let's pull all this together. Imagine our hero using the world globe as a football, but first trace off or square up the photo so that you have an accurate base.

Now let's look at the features.

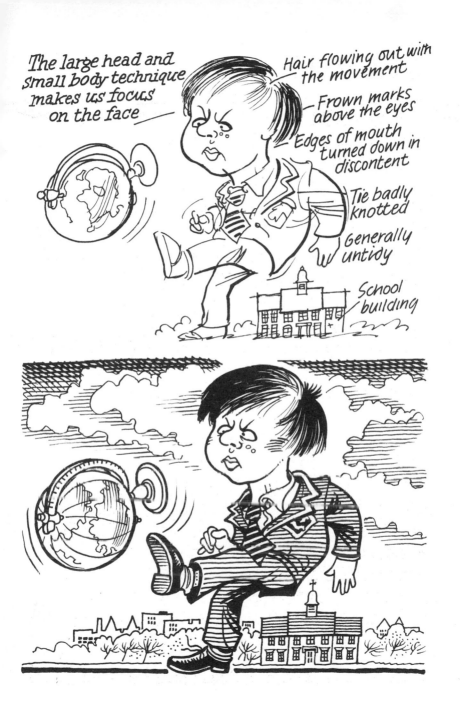

CARICATURE

Sometimes, try as we can, there doesn't seem to be a particular feature to pick up, but look again, every face has **something** special. This girl has a short upper lip so we pick up and exaggerate the slightly protuding front teeth.

Even an untidy hairstyle could be the jumping off point for a personal caricature.

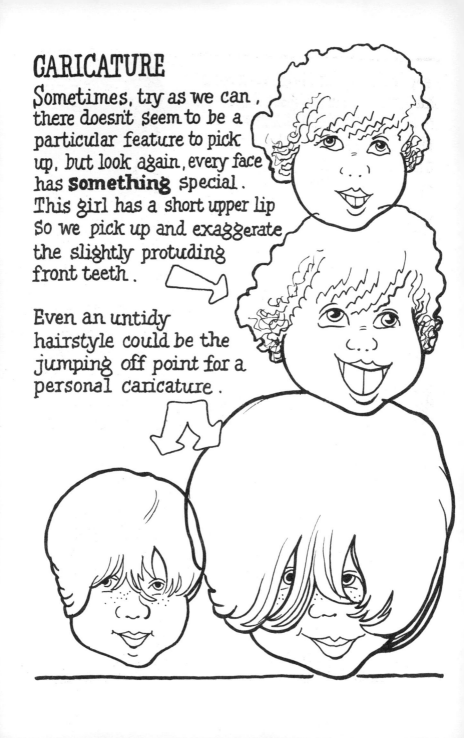

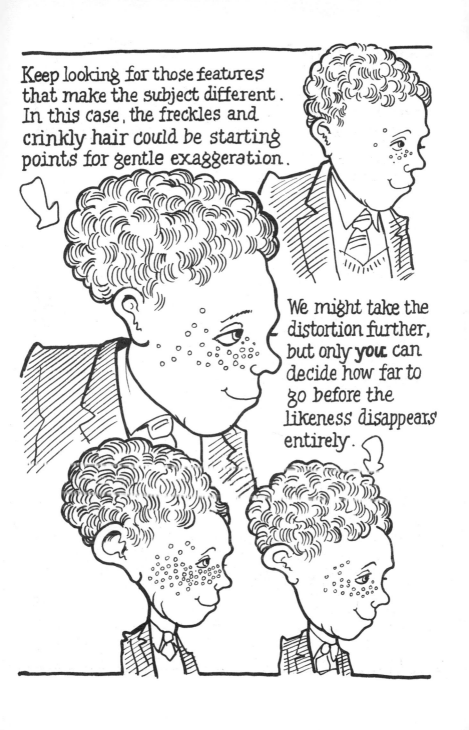

Keep looking for those features that make the subject different. In this case, the freckles and crinkly hair could be starting points for gentle exaggeration.

We might take the distortion further, but only **you** can decide how far to go before the likeness disappears entirely.

CARICATURE

Let's take a look at a favourite uncle. Perhaps he looks like this. We know that he's a jolly soul and that his most marked characteristic is a fondness for a little drink.

We could dress him up as a traditional drunk with red nose and cheeks, untidy hair and an unsteady posture.
Block out the figure as usual.

I think you ought to know your uncle quite well before showing him a drawing like this!

Unsteady feet

off balance figure

USING BLACKS

A solid black behind the main characters holds the picture together.

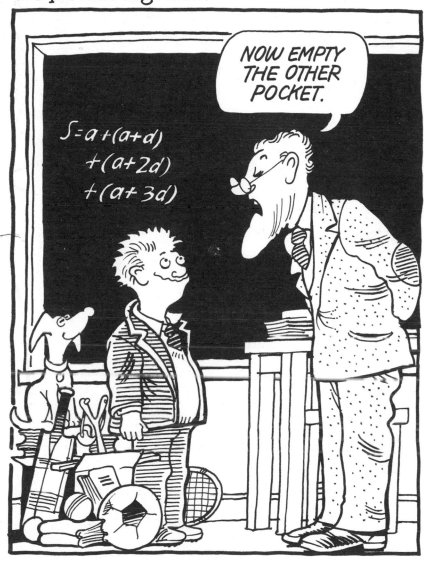

USING COMIC DRAWING

With a bit of imagination we can produce a lively personal invitation card.

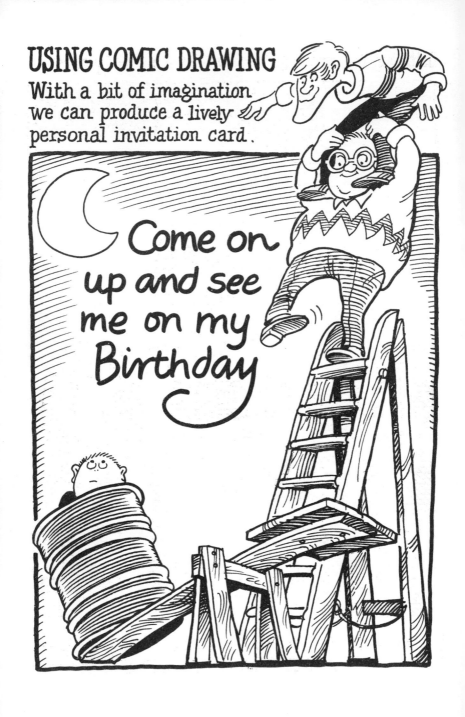

Lettering and drawing combine for a school poster.

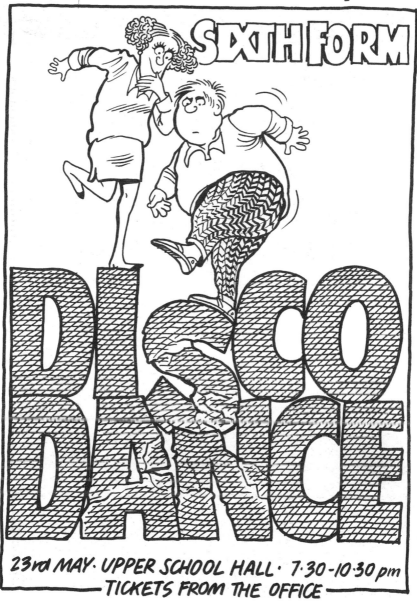

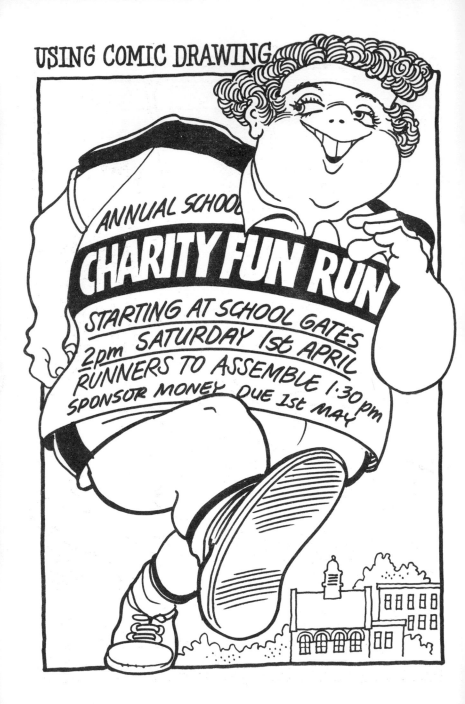

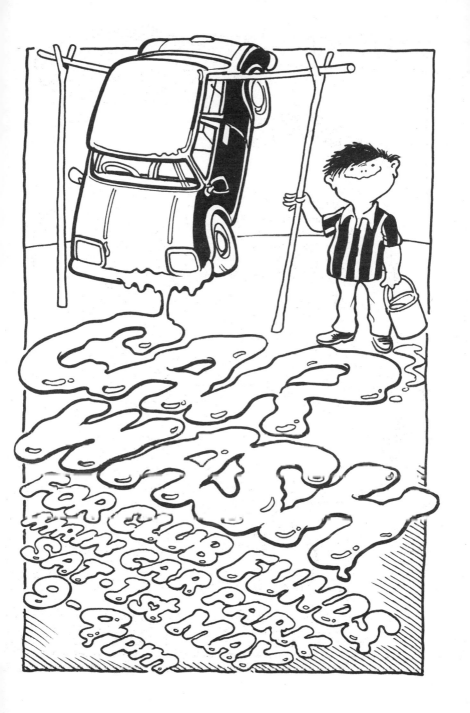

WHAT NOW ?

I hope I've shown that cartoon drawings can give pleasure to others and sometimes make the reader stop and think about the world around us.

COULD YOU MAKE A LIVING AT IT ?

Several hundred people **do** manage to work full-time at it in this country. A lot more are part-timers, or people who work in related trades like advertising or journalism. Cartooning is the poor relation of the arts. It certainly isn't taught at college, and I'm sure your careers master wouldn't approve !

Most professionals started like you – drawing for the fun of it, getting a kick out of seeing their stuff used in small magazines, then selling a regular strip or drawing a regular feature before realizing that, yes, perhaps they might make a success of it.

Anyway, the main thing for you **now** is to look at other cartoon drawings all the time. Come to understand how and why they work.

Don't worry about style, it will come. Just enjoy the doing of it ! GOOD LUCK.